The Lindisfarne Gospels

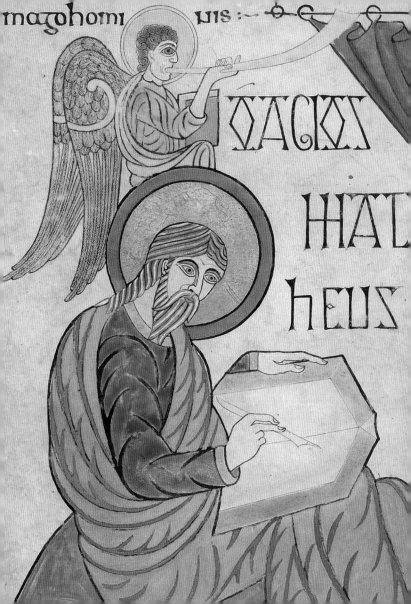

The
Lindisfarne
Gospels

A MASTERPIECE
OF BOOK PAINTING

Janet Backhouse

THE BRITISH LIBRARY

IOHANNEN :

rædinfalde ꞇ deanfalde god dir godr̄

+ Trinuſ & unuſ dr̄ evangelium hoc ante

+ Matheuſ exone xp̄i scripsiꞇ

+ Marcus exone peꞇri rec̄ips

+ Lucas deone Payli ap̄s scripſ

+ IOH. mꝑochemio deinde enuct̄uanꞇ
 verbū d̄o donante xp̄ꝰ rc̄o ſcripſ ꞇhalſeꞇ ꝥ

+ Eldfrið biſcŏp lindiſfearnenſiſ ecclſie
 he diſ boc awraꞇ æꞇ fruma ſode ꞇ rc̄e
 cuð beꞃce ꝺallum diem halꝫum. ꝺa. de
 in eolonde ꞃinꞇ. ꝺediluald lindiſfearneolondinꝫi
 hiꞇ uꞇa ꝺiðꞃyde ꞇſibelde ſua he velcuðꝫ.
 ꞇbillfrið þe oncꞃe he ꝺiꞃmiodade ꝺa
 ꝝiþꞃino ꝺaꞇe uꞇan on ꞃinꞇ ꞇhiꞇ ꝝ
 hꞃinade miðꝫolde ꞇmiðꝝimmūm ꝫc
 mið ꞃylfꞃe oꝝ ꞃiðeſ fuconleaꞃꝝæh :
 ꞇꞇ aldꞃed þbn indignuſ ꞇmiꞃꞃenimꞃ :
 mið ꝫodeſ fylcimꝫ ꞇrc̄i cuð berhꞇes
 hiꞇ oꝝ ꝫloeꝫade on englirc · ꞇhine ꝫihamadꞃ uocon
 mið dem dꞃium ꝺælꞇ. matheuſ ꝺæl
 ꝫode ꞇrc̄e cuðberhꞇi. Marꞯ ꝺæl
 ꝺæmbirc · ꞇlucaſ ꝺæl ꝺiom hionode
 ꞇæhꞇona ꞃeolſꞃeſ mið ꝺo mlude :
 ꞇrc̄i ioh ꝺæl þine ꞃeolſꞃe ꞇſeoven onꞃ
 ꞃeolſꞃeſ mið ꝫode ꞇꞃc̄i cuðberꞇi · ꝥe· he
 hæbbe ondꞃonꝫ ꝺenh ꝫodeſ milſiæ onheoꞃnꞃ
 ꞃ̄eel ꞃꞃibb oneondo ꝝonꝺ ꝫeonꝫ ꞇſiþꞃinꝫo
 virdom ꞃꞃnꞃ ꞇꞃo ꝺenh ꞃc̄i cuð berhꞇeꞃ eaꞃnunꝫa:ꞃ
+ Eadfrið · oediluald · billfrið · aldꞃed.
 hoc evanꝫe d̄o ꞇ cuðberhꞇo conſꞇꞃuxeꞃꞇ :

siꞇ atꝫ
ſaguiꞇ
ꝺonilꝫou
ſcᵉcyla con

ofmude pater wriꞇᵉ

ofmyde pꞃoꞇer wriꞇᵉ

inꝺenꝫil niſi ꞇiperagu ꞃ̄du noꞇꝫecede ꞇꝫꞃpꞃunꞇ

mellᵉ avuiꞇ ioh

sm̄ erelica
ꝺ̄ᵉo

:: alꝫnedi
naꞇyſ
aldnedꞃi
ꝫihamad:uocon
wolꝝ
bone mylieꞃ
filur eximiuꞃ
loquon

T HE LINDISFARNE GOSPELS, written and illuminated in the north-east of England at the very end of the 7th century, is one of the outstanding masterpieces of early medieval European book painting. The manuscript, which has survived the thirteen centuries of its history in virtually perfect condition save for the loss of its original binding, is of particular importance to all students of the art and culture of early Anglo-Saxon England, not merely for the quality and ingenuity of its decoration and the special interest of its complementary Latin and Old English texts, but also because it can be dated and localised with quite extraordinary precision. A colophon (1) added to the book about the middle of the 10th century records that it was made in honour of God and of St Cuthbert by Eadfrith, Bishop of Lindisfarne. Its binding was the work of his successor, Ethelwald, and ornaments of gold, gems and silver-gilt were added by Billfrith the anchorite. An interlinear translation into Anglo-Saxon was inserted by Aldred, 'unworthy and most miserable priest', who also wrote the colophon itself.

Lindisfarne, called Holy Island, lies just off the coast of Northumberland, a few miles south of the modern Scottish border. St Cuthbert was buried there when he died in AD 687. Eadfrith became Bishop of Lindisfarne in 698, the year in

I
Aldred's
colophon
(59 detail)

which Cuthbert's relics were raised from the tomb to the altar, and Ethelwald succeeded him in 721, having spent the years of Eadfrith's bishopric in the important post of Prior of Melrose. Both men had however been simple members of the Lindisfarne monastic community in the years immediately before 698 and it seems most likely that their work on the manuscript was done at that time. Nothing is known of Billfrith's career but the chronicler Simeon of Durham, writing about the Lindisfarne Gospels at the beginning of the 12th century, suggests that his jewelled ornaments were added to the volume at Ethelwald's request when he was bishop. Aldred, who added his translation about three and a half centuries later, was a member of the community of St Cuthbert while it was settled at Chester-le-Street, a few miles north of Durham. Although he was writing so long after the events which he records, his colophon is sufficiently specific in detail to suggest that it must have been based either on oral tradition within the community or on an earlier written source now lost.

The manuscript contains the texts of the four gospels according to the evangelists Matthew, Mark, Luke and John, in the Latin version revised in the late 4th century by St Jerome at the command of Pope Damasus. Known as the Vulgate, this version was widely adopted throughout the western world. The gospel texts are preceded by Jerome's introductory letter

to the Pope and by a series of canon tables, which provide the reader with a means of locating parallel passages in the four narratives. Each individual gospel has its own short introduction, a list of the passages to be used as liturgical readings and a list of feast days on which passages from that particular gospel should be read. The Lindisfarne text is a particularly accurate example of the Vulgate and the inclusion of the Neapolitan saint Januarius in the lists of feasts preceding Matthew and John suggests that it may have been copied from an earlier manuscript imported from southern Italy. The use of double columns for the text also suggests a late antique Italian exemplar. Assuming that this model did not actually belong to the monastery of Lindisfarne, the most likely local source for it would have been the monastic community at Wearmouth and Jarrow, situated near the mouth of the river Tyne about forty miles south of Holy Island. These twin houses were established in 674 and 682 by Benedict Biscop, and well supplied with books imported by the founder and his friend, Abbot Ceolfrith, who both made pilgrimages to Rome. England's first historian, the Venerable Bede, was a monk at Jarrow and was in close contact with Eadfrith of Lindisfarne at the beginning of the 8th century, composing for him two Latin *Lives* of St Cuthbert, the first in verse and the second in prose.

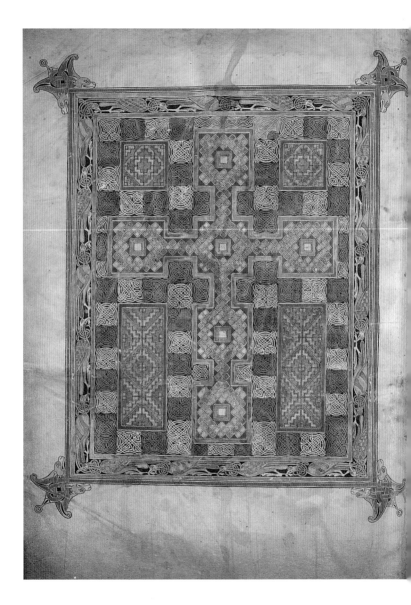

ϯ ail
ϯ ɣaʃe ϯ reglnia

onɜinnd pape pim tenu dapra canona
INCIPIT, PROLOGUS ·V· CANONUM;
·xii·

PLOGUM

pene .so.
ROBUSTA

p·nce mech nᵹ dᵹꝗ oꝗ
EEREHEROSEX

al ᵹe ᵹēᵹ depꝛeꞃ
UEEERHTBOSE

bɩppenᵹ pꞃ ɩꞇal
EXEHBLARIASERIB

alle ɜɩmb hꞃ ꝑ ꞇ coꞃꞇnoꝛᵹꞇ ꝑꝑa oᵹen ᵹoʃm ꞇ
ꞇuꞃaꞃum ꞇꞇo oꞃbe dɩʃpeꞃʃa quaʃɩ quɩᵹam aꞃbɩ
ꞇꝑpelɩ
um

Previous
pages
2
*St Jerome's
letter to Pope
Damasus:
carpet page
(f.2b)
and*
3
*initial page
(f.3)*

The English translation which Aldred added to the gospels in the 10th century, compromising the original perfection of Eadfrith's pages and perpetrating what would nowadays be regarded as a major act of vandalism by writing between his original lines of Latin text, is of the greatest interest in its own right. Although it treats the Latin word by word and is thus in no sense a work of literary merit, it does represent the earliest version of the gospels in any form of the English language. Antiquarian interest in this translation played an important part in safeguarding the manuscript after it had been seized from its medieval home at Durham in the course of Henry VIII's dissolution of the monasteries. Aldred's work became known to students of the Anglo-Saxon language and words from his gloss are included in the first ever dictionary of it, compiled during the reign of Elizabeth I.

Eadfrith wrote and illuminated his gospels on 259 leaves of well-prepared, good quality vellum. In two or three places in the manuscript, tiny imperfections in the skins have allowed traces of reddish-brown hair to remain on the pages, suggesting that the animals from which the book is made were cattle rather than sheep. The spine lines of the animals run horizontally across the open volume. Each double sheet of vellum is approximately 20 inches (500 mm) wide, representing a single animal, so a considerable herd would have been required

4
*Arcad
canon ta
(f.15*

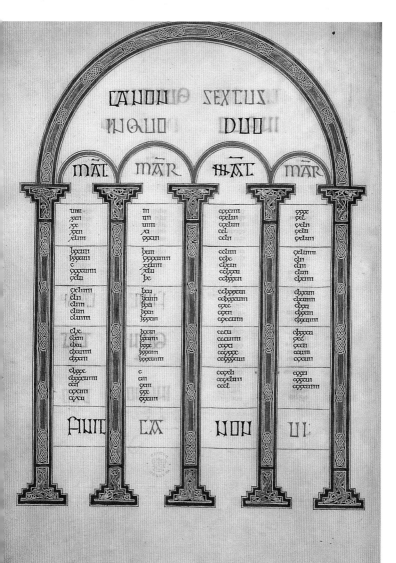

to make up the book. Cattle, an important source of food, were widely kept in 7th-century England. Even though the early monastic community of Lindisfarne deliberately avoided amassing worldly wealth, we know from Bede's *Ecclesiastical History* that cattle were kept in the time of the founder, St Aidan, and he also mentions them in connection with Bishop Eadbert, Cuthbert's successor, in whose time the Lindisfarne Gospels was almost certainly made. The monks may also have had access to skins from the royal herds or from those of other lay benefactors. It is interesting to note that when the hermit Ethelwald, Cuthbert's successor as resident on the Inner Farne, wished to make urgent repairs to the cell there, he was supplied with a calfskin to nail to the wall. This is recorded by Bede, not as an unusual event but because fragments of the skin later proved to have acquired miraculous qualities through association with St Cuthbert's former dwelling place. In order to fit them for the making of the manuscript, the skins selected for its pages would have been soaked, stretched, scraped clean and cut to size before being arranged in piles of four sheets at a time, which were then folded in half to make gatherings of eight pages.

The areas on which the text was to be written were carefully measured and marked out, their framework identified by pricking through each group of eight leaves with a sharp point.

hunda bebeadande

tertio commendans
mid hrecing honda
extensione manuum
rahte † him þæt roder
significat ei quod aquas
dæde uentreowand mid þrowinge
morte fore martyrio
sge gefernad
coronandus

quae lectio cum in natale
sancti petri legitur
a loco incoatur
quo ait

Dit simon
petro ihs simon
iohannis
diligis me plus his
usque ad locum ubi dicit
significans qua morte
clarificaturus esset dm
cum uero in natale sci
iohannis euangeliste in
choancta est a loco quo
ait dicit ei hoc est dns
simoni petro sequere me
usque ubi dicit & scimus
quia uerum est
testimonium eius

explicit secundum
iohannen
sci iohannis
apostoli &
euangelista
post epiphania
dnica prima
post ephipania dnica
secunda
inuelanda
in dedicatione sce mariae
dnica ii xlgsima paschae
post octabas dnm in ihu xpi
post iii dnicas cleephipania
demuliere samaritana
de xlgsima feria iiii
in sci angeli & in dedicatione
fontis
couchiana
in natale sci andreae
couchiana
post iii dnicas xlgsima
feria iiii
post iii dpica xlgsima feria
iiii

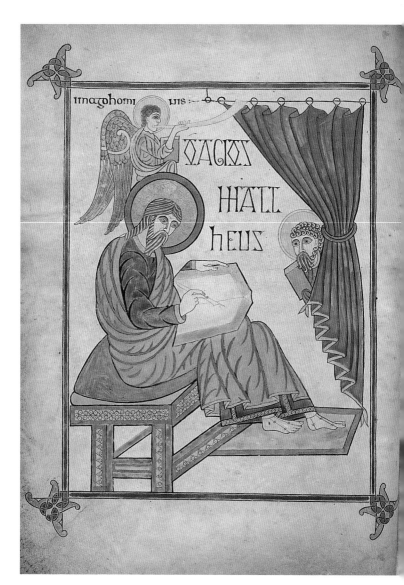

imago homi nis

ɪɧACIƆS HATT heus

Lines were then ruled, page by page, with a hard dry point, very lightly in order to be as unobtrusive as possible. Eadfrith wrote in a good, dense, dark brown ink which contains particles of carbon from soot or lamp black. His pens, which must have been frequently renewed, would have been cut from reeds or quills, both readily available near the monastery. The script in which the text is written (5) is known technically as 'insular majuscule'. Originally developed in early Christian Ireland and introduced into England by the first missionaries, it rapidly spread throughout the British Isles and was used in parts of continental Europe influenced by Irish and Anglo-Saxon missionaries in the 7th and 8th centuries. Aldred's gloss is also written out in a characteristically insular script, this time the cursive and time-saving form used for business and legal documents or for transcribing less formal books, known as 'insular minuscule'.

The majority of the pages in the Lindisfarne Gospels are devoted entirely to written text and these are virtually unornamented save for patches of green and yellow pigment in initial letters, which are also usually outlined with small dots of red. The principal decoration is reserved for fifteen spectacular pages marking major divisions in the book. Each of the four gospels is introduced by a sequence of three grand illuminated pages, first a miniature representing the relevant

6
Matthew
(.25b)

Overleaf
7
St Matthew:
carpet page
(f.26b)
and
8
initial page
(f.27)

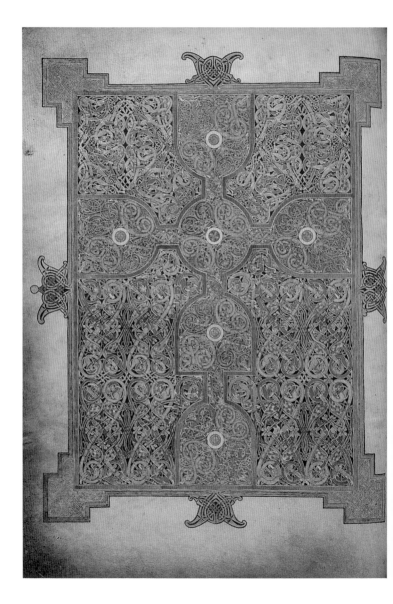

✝ ihs xps · Matheus homo

incipit euangelii
genelogia mathei

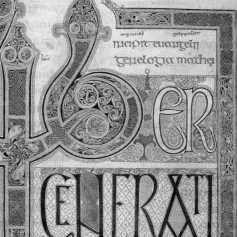

LIBER GENERATI ONISIHU XPIFILIIDAVIDFILIIABRAHAM

evangelist and then, on the following opening, a page of pure decoration loosely based on the form of a cross (thus usually referred to as a 'cross carpet page') opposite a page on which the opening words of the text are written out in decorated capitals, preceded by a magnificent initial. An additional initial page in Matthew (*9*) marks the beginning of the Christmas Gospel. A further carpet page and initial page are provided at the very beginning of the manuscript to introduce St Jerome's letter to Pope Damasus. The book also contains a sequence of sixteen arcaded canon tables (*4*) and a number of smaller initials marking prefatory materials attached to the gospel texts (*5*).

 The four evangelists are portrayed as seated figures in late classical dress, each identified by an inscription giving his name in Greek but transliterated into the Latin alphabet. Matthew (*6*) is shown writing into a book balanced on his knee, watched by a mysterious figure half hidden by a curtain whose presence has yet to be satisfactorily explained. Mark (*15*) writes on a single sheet placed on a small desk to his right. A small book is clasped in his left hand. Luke (*20*) is writing horizontally on a scroll draped across his knees. John (*25*), the only one of the four placed directly facing the reader, also holds a scroll across his knees, but he appears to be expounding its contents and no writing implements are shown. All four evan-

ongunned godspell æþe matheus

INCIPIT EUANGELI um secundum mattheu:
cuftar

XPI

uutedlice
puæ
cniepcio endu
peppo

yod lice

AUTEM GE

cynnytecenure tonteupeýu puuetður per mid þy

RATIOXILERATCUM

per in potodes tbebodon tbepaytenid tbetahe

ESSHOSBONEAM

modor hip

MATER EIUS MARICIOSEBH

gelist figures are much more lifelike than those which appear in other insular gospel manuscripts surviving from the 7th and early 8th centuries. They appear to have been adapted from late antique models, probably drawn from a manuscript or manuscripts imported into England from the Mediterranean area. As in the case of the text, the most likely source of such a model would have been Wearmouth and Jarrow and it is interesting to note that the Lindisfarne figure of St Matthew is identical with the figure of the Prophet Ezra in the Codex Amiatinus, a great one-volume Bible written and illustrated by Wearmouth/Jarrow craftsmen during the time of Abbot Ceolfrith and taken by him on his last journey towards Rome in 716. This manuscript, originally one of three identical bibles, is now in the Laurentian Library in Florence. Only one other human motif is included in the Lindisfarne Gospels. It is a tiny profile head incorporated into the decoration of the initial page to John (*10*), attached to the letter 'c' in the word 'principio'.

10
*Decorative use
of a human
face
(detail of 27)*

Each of the evangelists is accompanied by his traditional symbol, that of Matthew a winged man, that of Mark a lion , that of Luke a calf and that of John an eagle (*11*). All four are shown winged and the first two are blowing trumpets. The two animals are carefully drawn and a distinction is made between the soft fur of the one and the smooth hair of the other.

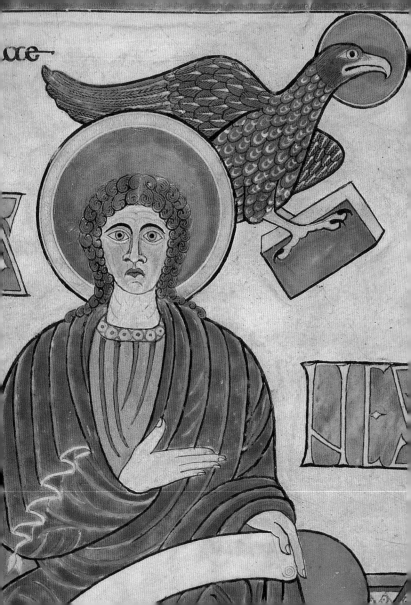

In each case the feathered wings are realistically portrayed. John's eagle closely resembles a living bird and may even reflect first-hand observation from the life, so carefully are the various grades of feather depicted. Animals and birds are indeed a feature of Eadfrith's decorative vocabulary throughout the manuscript and, although it would be anachronistic to suggest that he was a naturalist in the modern sense, there are numerous indications that he was very much aware of and receptive to the rich natural world around him. It is interesting that Cuthbert, in whose honour the book was made, is the only purely English saint of the period whose life includes a series of miracles featuring animals and birds, each of which is appropriate to the region in which he lived. The Lindisfarne Gospels is the first surviving insular manuscript in which birds are a major element of the decoration, though the Mediterranean models probably available to the artist may have included some bird ornament, particularly in the canon table arcades. Eadfrith's birds are, however, quite distinctive, with strong curved beaks, long talons and sharply patterned wings. Particularly good examples may be seen in the borders of the Jerome carpet page (2) and of the Luke initial (22), and they are woven together all over the carpet page to John (26). It is easy to see in their features a reflection of the characteristics of the cormorants and shags so prominent in the sea bird

I I
John and
his eagle
ail of 25)

population of the Farne Islands, just south of Holy Island. By contrast animals, usually in the form of stylised dog-like creatures, had been a feature of Anglo-Saxon ornament long before the advent of Christianity, so most of Eadfrith's beasts follow a pattern already familiar. Exceptions are his cats, the finest and most recognisable of which forms the right-hand margin of the Luke initial page (*12,22*). Its back legs and tail appear at the top, above the first line of decorated capitals, and its head and forepaws turn inwards towards the 'm' of 'narrationem' on the bottom line, apparently intent upon the mass of birds on the other side of the page, from which it hopes to supplement the eight already inside its elongated body. Although they add nothing to the general design of the page, this cat has elegant whiskers, drawn in so delicately that only the closest scrutiny reveals them.

Eadfrith's decorated pages incorporate many different types of ornament, most of which can also be seen in the work of craftsmen skilled in other media as well as in the pages of fellow illuminators. The straightforward ribbon interlace which forms the basis of the Mark carpet page (*16*) is featured in panels of the great stone cross at Bewcastle in Cumbria, which dates from the 8th century. The step patterns in the roundel at the centre of the same page are reminiscent of jewellery and may be compared with the gold and garnet cellwork on the

12
The cat
(detail of 22)

24

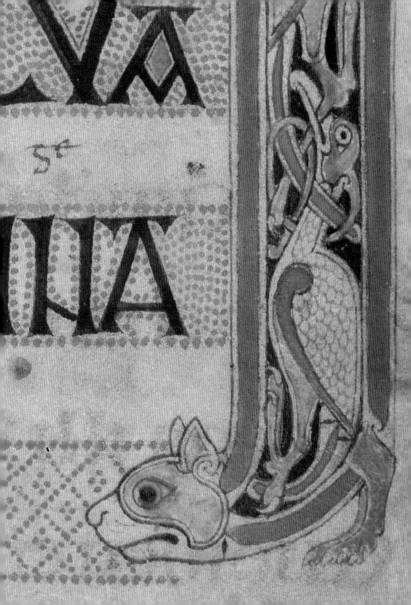

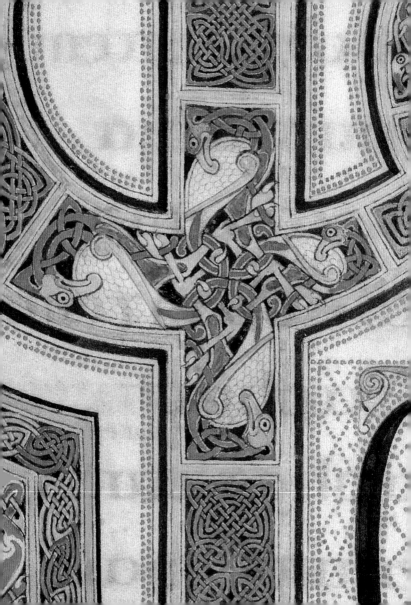

shoulder clasps from the early 7th-century Sutton Hoo ship treasure. Similar step patterns are also featured in enamelwork bosses on the 8th-century Ardagh Chalice in the National Museum of Ireland. There they are set off by patterns formed of tiny dots punched into the silver of the body of the vessel, just as tiny dots of red lead pigment are arranged by Eadfrith to set off the coloured capitals on his initial pages, especially that to Luke (22). The centre of the initial to the Christmas Gospel (9) features a cascade of spiral motifs, echoing enamel work of an earlier period, seen in the decorative escutcheons applied to hanging bowls, magnificent examples of which were found at Sutton Hoo. Similar spiral designs are engraved onto the silver surfaces of the 8th-century Tara Brooch, where they are filled with niello. This too is in the National Museum of Ireland. All the elements mentioned can be seen time and time again in varying combinations on the major pages of the Lindisfarne Gospels and are adapted to provide decoration for the canon tables and the minor initials in Eadfrith's book.

The complexity of Eadfrith's designs is often breathtaking, but evidence of the methods which he used to lay them out is relatively meagre. Frequent small holes on the major decorated pages do indicate that he made extensive use of compasses and it is also possible to see where he ruled with a straight edge. A fine grill underlies some sections of his work. Each of the car-

pet pages is symmetrical in overall design and it is therefore easy to propose strict mathematical principles for their structure. However, very little of the content of the major initial pages could have been constructed mathematically as the varied and often awkward shapes involved are far too complicated and disparate to allow it. A great deal must have been due solely to the accuracy of Eadfrith's eye and the skill and steadiness of his hand. On the backs of these pages there is some evidence of sketching, occasionally very detailed, undertaken with some form of lead point. In one or two places a single hair, trapped in the paint surface and visible only under magnification, shows that colour was applied with a brush. How the form of each design was initially arrived at we shall never know. There must have been some kind of preliminary sketching, possibly involving the use of wax tablets, the contemporary form of notebook, for crude outlines. More delicate work would have needed a finer surface. Maybe offcuts of the vellum from which the pages were prepared were used by the artist for experiments. Material such as this does not survive.

The colouring of the Lindisfarne Gospels is particularly rich and varied for an English manuscript so early in date. A wide range of pigments was used, derived from animal, vegetable and mineral sources available both locally and through Europe-wide trade links. Although it is not possible to rob the

manuscript of colour specimens for scientific analysis, much has been learned through close examination of the paint surfaces under high magnification, using variable sources of light. Red and white lead, orpiment (yellow arsenic sulphide), kermes (a red derived from an insect living on the kermes oak in the Mediterranean area), verdigris (green copper acetate), indigo (blue extracted from plants, possibly woad rather than true indigo, which comes from the east) and folium (pinks and purples derived from the tournesol plant) have all been identified in the manuscript. The most exotic pigment is an ultramarine blue derived from lapis lazuli, only obtainable from Badakshan and brought to Northumbria by who knows what long and tortuous chain of trading links. Combinations of these various pigments were used to provide many other subtle shades. Gold is confined to a few tiny patches on the Matthew and Luke (*14*) initial pages, where it is used very tentatively. Eadfrith clearly did not regard it as an appropriate substance for use on the painted page, though we know from Aldred's colophon that it was applied, apparently quite lavishly, to the outer surfaces of the book.

The original binding of the Lindisfarne Gospels has long since disappeared, very probably torn from the manuscript by Henry VIII's commissioners for the sake of the bejewelled gold and silver ornaments which Billfrith had added to it in

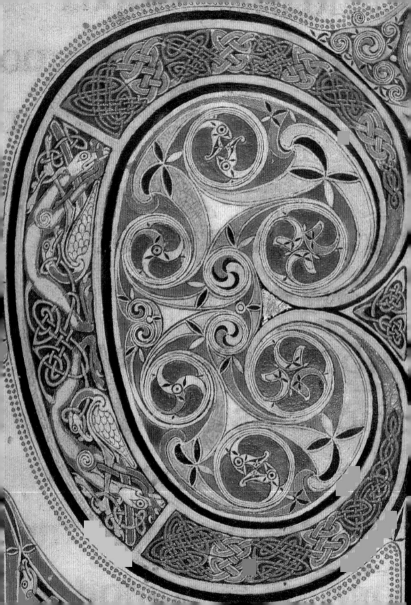

the 8th century. The binding itself, according to Aldred, was provided by Ethelwald and was apparently made of decorated leather 'as he well knew how to do'. One decorated leather binding of English manufacture does survive from this period and has the distinction of being the oldest European binding still enclosing the book for which it was originally made. This is the binding of the St Cuthbert Gospel of St John, owned by the Society of Jesus and now on long-term loan in the British Library. It is made of dark red goatskin over beechwood boards and ornamented with a stylised plant design, raised over cords and framed in panels of ribbon interlace once coloured green and yellow. The manuscript inside it is written in a fine formal uncial script of the type associated with the scriptorium of Wearmouth and Jarrow. This little book was found inside St Cuthbert's coffin when it was opened at the time of his translation into the newly-built sanctuary of Durham Cathedral in 1104. Today the Lindisfarne Gospels is once again bound in silver and gemstones, in an imaginative reconstruction of an Anglo-Saxon binding created in 1852 by a London silversmith at the expense of Bishop Edward Maltby of Durham.

It is very hard to assess with any confidence just how long the production of a manuscript as elaborate as the Lindisfarne Gospels is likely to have taken. Its traditional association with

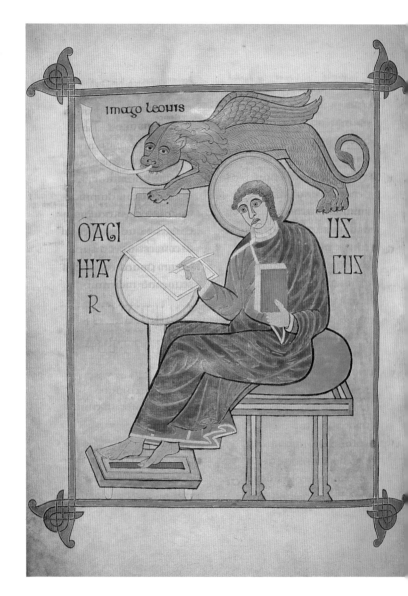

the elevation of St Cuthbert's relics in 698 suggests that the work must have been carried out in the period which had elapsed since the saint's death in 687. Painstaking scrutiny of the manuscript page by page has revealed no obvious hiatus in execution, suggesting that this was an ongoing project, achieved without major interruptions. The artist's skills appear to have refined as the work progressed, from the relative simplicity of the decorated pages introducing St Jerome's letter to the Pope (2, 3), to the immensely complicated and varied ornament of the opening of St John's Gospel (26, 27). Evidence of occasional amendments and changes in design underline the fact that scribe and artist were one and the same. One or two attempts have been made to replicate particular aspects of the work in order to arrive at some sort of time scale. It has been suggested that to apply the 10,600 dots of red lead on the Luke initial page alone might have taken at least six hours. However, far too little is known about the circumstances under which Eadfrith worked to allow of any realistic estimate. Both the length of the working day and the extent to which a master craftsman engaged upon the making of a copy of the gospels would be obliged to undertake routine religious duties are unrecorded. The geographical position of Holy Island guarantees that it is subjected to some very extreme weather, especially during the winter months. In the mid

15
Mark
(f.93b)

Overleaf
16
*St Mark:
carpet page*
(f.94b)
and
17
initial page
(f.95)

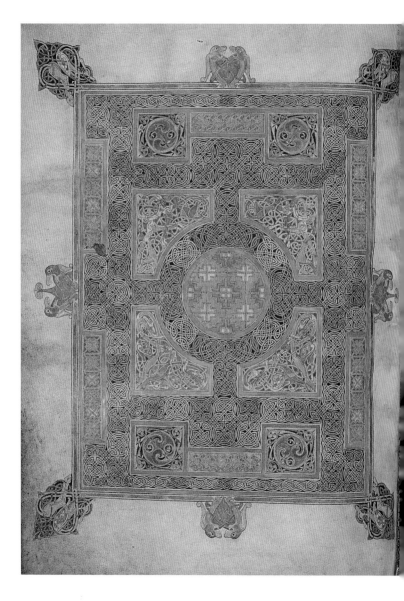

onginneð god ypped ...

94

mar
cus

leo

INI
TIU
EUA
LIII

ce
egypt

IHU
XPI
FILII
DI
SICUT

godspelles

h: elenðer

XPIAUOISICUT

SCRIBLUHEST

INESAICA BROBBEA

8th century an abbot of Wearmouth wrote to one of the Anglo-Saxon churchmen on the continent, blaming the unusual severity of the winter weather for inhibiting the hand of his scribe, so that he had been unable to deliver some much-needed books requested of him. The accommodation provided for an Anglo-Saxon monk will have been very primitive and sources of artificial light poor. These various considerations do however strengthen the argument for assigning the making of the manuscript to the period before Eadfrith became Bishop of Lindisfarne in 698. The record of St Cuthbert's own activities when he was bishop suggest that much time was spent in travelling widely around the kingdom, with little opportunity to enjoy the protracted tranquillity needed for work on the Gospels when conditions were favourable.

18
Section of the Matthew carpet page, including a 'deliberate mistake' (detail of 7)

One very intriguing characteristic of Eadfrith's work deserves special notice. This is his apparent tendency to introduce occasional imperfections into his complex patterns or to leave minor areas apparently unfinished. Lines of decorated capitals remain uncoloured on three of the five major initial pages (*8, 9, 22*). Harder to find but unarguably intentional are the 'deliberate mistakes' on two of the carpet pages. On the one preceding Matthew (*18*) a single creature in the lower right-hand section of the page is jointed with a tiny ink-drawn

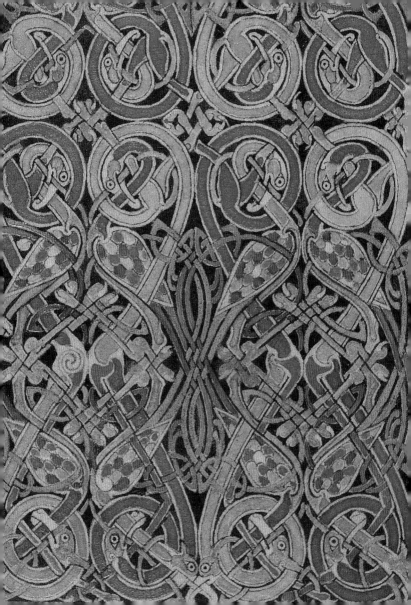

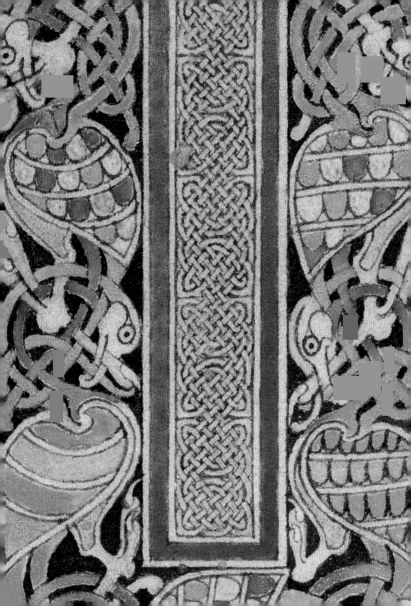

spiral in place of the interlocking patches of colour found everywhere else in the design. On the John carpet page (*19*) just one of the 78 birds woven together to form a background to the basic cross shape has a wing devoid of the ink lines which should divide it up into cells. It is hard not to interpret these small features as a studied attempt to avoid any claim to perfection for Eadfrith's masterpiece, perfection being appropriate only to the Creator. There is considerable evidence of the contemporary regard in which this level of craftsmanship was held and of its frequent association with saintliness. In the Latin poem *De Abbatibus*, which describes an anonymous Northumbrian monastery founded in the early 8th century with help and advice from Eadfrith as bishop, we are told of an Irish scribe named Ultan, the bones of whose hands were revered as sacred relics by the community because in his lifetime they had inscribed the mystical words of God. In his Life of St Columba of Iona, Adamnan records how books written out by the saint proved to be miraculously impervious to damage by water. It is not unlikely that Eadfrith's own superb craftsmanship was regarded as a significant factor when the time came to choose a new bishop of Lindisfarne in 698.

19
tion of the
hn carpet
, including
'deliberate
mistake'
ail of 26)

To MODERN EYES, looking back over a distance of thirteen centuries, the Lindisfarne Gospels seems an unparalleled, almost miraculous phenomenon, in terms both of its great antiquity and of its quite extraordinary beauty and completeness. It is very hard to judge just how rare such a manuscript would in fact have been at the time when it was made, at the end of the 7th century. The Four Gospels, taken together, constitute the basic text of the Christian faith, providing an essential narrative of the life of Christ, a foundational source for study and teaching, and a necessary ingredient of the liturgy, during which gospel passages were assigned to be read each day. Every priest and every religious community must therefore have had access to some sort of copy of the gospels, though the majority would probably have been very simple books designed merely to provide a straightforward text. Very little evidence of these once comparatively numerous books has survived, though the British Library does have one 8th-century gospels attributable to Northumbria which contains only minimal decoration (Royal MS I B. vii). Apart from the Lindisfarne Gospels itself, there are only five gospel manuscripts containing substantial decoration that can be attributed to this period. Two, which have not been firmly connected with any particular centre, are certainly earlier than Lindisfarne. The remaining three are all apparently attributable

to the Lindisfarne scriptorium itself. This cannot possibly be anything but a very distorted picture as contemporary Northumbria contained a multiplicity of extremely important religious communities which must have had impressive gospel books. These include Whitby, where writing implements have been found in excavations, Ripon, to which St Wilfrid is known to have given an extremely splendid gospels written out on purple parchment in letters of gold, and Melrose, where St Cuthbert himself began his monastic career.

The two manuscripts earlier in date than Lindisfarne are a series of fragments in the library of Durham Cathedral (notably parts of MS A.II.10), which may be as early as the middle of the 7th century, and the Book of Durrow (MS A.4.5(57) in the library of Trinity College, Dublin), thought to date from about 675. Both are ornamented with decorative elements parallel to those in the Lindisfarne Gospels but are obviously far less sophisticated in design and execution. The three books which can apparently be attributed to the Lindisfarne scriptorium, and which are therefore closely associated with Eadfrith's work, are the Durham Gospels (MS A.II.17 in the Cathedral library), the Echternach Gospels (MS lat. 9389 in the Bibliothèque Nationale in Paris) and the Otho-Corpus Gospels (now divided between the British Library, Cotton MS Otho B. v, and Corpus Christi College,

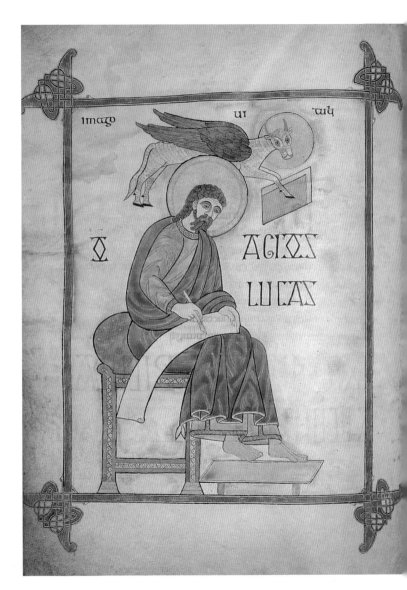

Cambridge, MS 197B). The Durham and Echternach Gospels, although they are at first sight strikingly dissimilar in appearance, are thought to be the work of a single scribe and artist, a very great craftsman who must have been Eadfrith's exact contemporary and may even have been his mentor. The Durham book, now very badly damaged and incomplete, is superficially quite closely related to the Lindisfarne Gospels, being written out in a fine insular majuscule script ornamented with decorated initials, both large and small. It is likely that it once contained evangelist miniatures and carpet pages and it still includes a miniature of the Crucifixion, placed at the end of Matthew, which suggests the original presence of several scenes from the Life of Christ, not provided for in the Lindisfarne Gospels. This book probably always belonged to the Lindisfarne community and has remained with the relics of St Cuthbert at Durham until the present day.

The Echternach Gospels, originally owned by the abbey of Echternach, founded by St Willibrord in 698, is an altogether simpler book, written out in two columns in an elegant and fluid insular minuscule, probably chosen for speed of execution. Its decoration is confined to a full-page miniature of the symbol of each evangelist and a large initial at the beginning of each gospel. These are however executed with great assurance and panache. The Otho-Corpus Gospels is closely re-

20
St Luke
(f.137b)

Overleaf
21
St Luke:
carpet page
(f.138b)
and
22
initial page
(f.139)

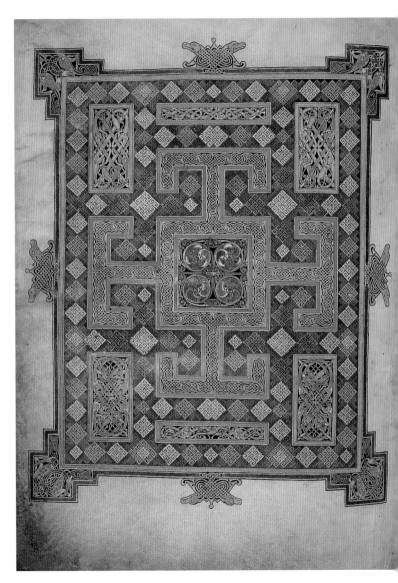

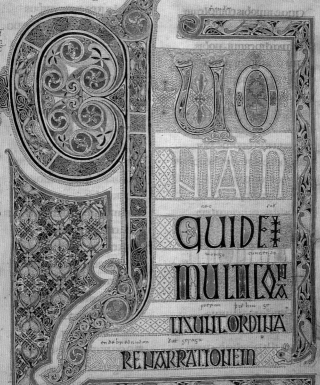

QUO
NIAM
QUIDE⹂
MULTI CO
NSUNTORDINA
RENARRATIONEM

lated to the Echternach book. In part very badly distorted and discoloured as a result of the fire which swept through the Cotton Library in 1731, it retains only the evangelist symbols for Mark and John and the corresponding large initials. A third symbol, that of Matthew, is described in an old catalogue and copies of some of the lesser initials were made in the early 18th century, before the fire. Two scribes were responsible for its text and one in particular wrote a majuscule very close to that of Eadfrith. This manuscript was at Canterbury apparently from a very early date and it seems likely that both it and the Echternach Gospels were commissioned from the outset for use outside Lindisfarne. This interpretation is strengthened by the fact that Echternach is written on vellum apparently prepared by continental methods and therefore presumably imported. Anglo-Saxon churchmen working in the continental missionary centres later in the 8th century did on occasion order books to be made for them by English scribes and sometimes provided at least part of the materials required. In 735-6 St Boniface wrote to the Abbess of Minster in Thanet for the Epistles of St Peter to be written out for him in letters of gold, himself supplying the gold for the purpose.

These four gospel manuscripts suggest a considerable range of scribal activity at Lindisfarne in the years around the time

of St Cuthbert's elevation to the altar. Eadfrith was clearly only one of a number of craftsmen capable of the highest grade of workmanship. Evidence from less formal manuscripts supports the view of a substantial scriptorium. Its output must have been considerable and seems to have included work undertaken for other communities. The Lindisfarne Gospels does however stand somewhat apart in two respects. In the first place its range of pigments seems altogether more ambitious than those seen in the other three manuscripts. Both the Echternach Gospels and the Otho-Corpus book have a very restricted colour range. The first relies on red, yellow and purple, the second on red, yellow and green for all its decorative schemes. Even the Durham Gospels, insofar as it is possible to be certain from the comparatively small amount of decoration remaining in it, did not contain anything approaching the range of pigments used by Eadfrith for Lindisfarne. Secondly Lindisfarne seems to be rather more outward looking in the choice of models to represent the four evangelists. The two less elaborate manuscripts contain no true figure painting at all. The Durham Gospels, though apparently including the more ambitious scheme of illustration, does not seek to emulate the naturalistic appearance of Mediterranean figure painting, unless its lost evangelist figures were very different in style from the figures in the crucifixion miniature.

mech

The evangelist portraits in the Lindisfarne Gospels, recognisably derived from late antique sources and accompanied by transliterated Greek, suggest a strong awareness of trends filtering in from the south through some of the more recently founded communities such as Wearmouth (674) and Jarrow (682), to which Eadfrith was later to turn for the Lives of St Cuthbert in verse and in prose by the Venerable Bede.

ALDRED'S COLOPHON tells us that the Lindisfarne Gospels was written in honour of God and of St Cuthbert. All splendid gospel books of their very nature honour God, their visual richness within and without glorifying the written record of the Life of Christ, the basis of the Christian religion, in the eyes of what was still at this time a largely illiterate and very recently pagan population. The specific reference to St Cuthbert, coupled with the fact that Eadfrith was consecrated bishop in the year of the saint's elevation and the well-documented long-term association of the manuscript with the relics of the saint, has always been taken to indicate that the manuscript was written and illuminated as a feature of the preparations for the elevation of the relics in 698. This event did in fact constitute a very distinct landmark in the history of the Lindisfarne community.

The monastic community of Lindisfarne was first established in 635 when the Irish St Aidan, with a small group of companions, came from Iona at the invitation of the Christian King Oswald, newly come to power, to preach the Christian faith to his pagan Northumbrian subjects. A suitable site on Holy Island, conveniently close to Oswald's royal stronghold on the great crag at Bamburgh, had been assigned to them by the king. Bede gives a graphic description of its situation, cut off twice daily from the mainland by the rising tide, which has led historians to assume that the newcomers, accustomed to the secluded island setting of Iona, were being offered the comfort of the most appropriate available surroundings.

To the modern traveller, speeding in comfort along the Great North Road or on the railway line between London and Edinburgh, Holy Island appears romantic and remote, emerging hazily from a background of sea and sand, crowned dramatically by the modern castle that now occupies the rock known as the Beblowe Crag. Twentieth-century methods of transport, dominated by the motor car, have in fact exaggerated the isolation of Lindisfarne. A holidaymaker based in Bamburgh and planning to make a day trip to the priory ruins on Holy Island today faces a drive of some 18 miles, culminating in a narrow winding lane and a long causeway generously supplied with warnings of the very real dangers of tri-

fling with a rising tide. In Aidan's day he would probably have gone there direct by boat, a distance of only about 6 miles, or maybe walked across Budle Bay and up Ross Back Sands, to be ferried the last few hundred yards to the monastery from the nearest point on the opposite shore.

It is most unlikely that Holy Island was uninhabited before Oswald placed his missionaries there. It boasts a sheltered, south-facing harbour and is dominated by a natural 100-foot high vantage point, the Beblowe Crag, which is a landmark for many miles, both up and down the coast and far inland. The sea route along the coast was of major importance as a highway during the 7th century. Bede records that Aidan's predecessor as potential apostle of Northumbria, the Roman St Paulinus, chose to travel by boat when he fled back to Kent with the widow of King Edwin in 633, after her husband had been defeated and slain by the pagan King Penda of Mercia. Any sense of isolation initially felt by the monks of Lindisfarne when they settled on Holy Island in 635 is likely to have been a psychological one, inspired by the knowledge that theirs was the sole Christian religious community in the kingdom. This did not long remain the case. With determined support from Oswald, Aidan and his companions soon succeeded in spreading their Christian message. Over the next few decades numerous monastic communities of both men and women

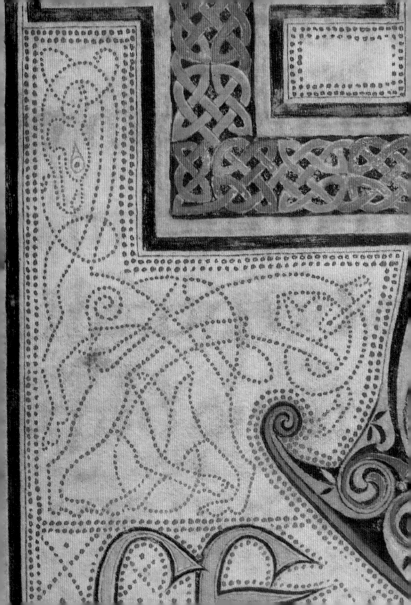

were founded, often with close links to the ruling family, and it is fascinating to note how many of these, including Hartlepool, Whitby, Wearmouth, Jarrow and Coldingham, occupied coastal or near-coastal sites with access to convenient landing places.

The first monastery on Holy Island, as described by Bede, was a very simple settlement in which no special provision was made for visiting dignitaries. When the king made the short journey from Bamburgh to pray there, accompanied by a few of his thegns, he was content with the facilities available to the monks themselves. Aidan died in the summer of 651 and was buried in the monastic cemetery. His successor Finan, also sent from Iona, did build a church more suited to the dignity of an episcopal see, and some years later Archbishop Theodore dedicated it in the name of St Peter, but even this was made in a simple Irish fashion of oak logs, thatched with reeds. In Finan's time ever closer contact with the churches of southern England and with Gaul and Italy began to underline certain fundamental differences in practice between the Irish and Roman churches, notably a substantial variation in the method of calculating the date of Easter, an important secular as well as a religious celebration. Finan died in 661. Three years later his successor Colman finally lost this debate at the Synod of Whitby and made a personal decision to return to Iona, ac-

companied by a number of like-minded clergy, rather than abandon the familiar practices of the Irish church. He took with him from Lindisfarne part of the relics of St Aidan, instructing the community to place the remainder of his bones in the sanctuary of Finan's church with all the honour due to so holy a man. He also petitioned the king to entrust supervision of the reform of Lindisfarne to Abbot Eata of Melrose who, although he now accepted Roman practices, had been one of Aidan's first English disciples. In the same year natural disaster struck when an outbreak of plague carried off large numbers, including Tuda, the new Bishop of Lindisfarne.

At some unrecorded date thereafter Eata transferred Cuthbert from Melrose to Lindisfarne to reform the customs of the monastery. His biographers, writing after the establishment of his cult there, are careful to stress his earliest associations with Aidan and the community. We are told that his initial entry into the monastic life was inspired by a vision of Aidan's soul carried up to heaven by angels on the night of his death. Bede also says that the young Cuthbert had been fully aware of the presence of holy men and teachers at Lindisfarne but chose to enter at Melrose purely for the reputation of Boisil, who became his mentor. For some years he worked with the community, establishing new customs not by coercion but by exhortation and force of example. Eventually

he was permitted to carry out a long-cherished ambition of withdrawing into solitude to live the life of a hermit. He chose to go to the Inner Farne, a small island in a group some miles to the south-east of Holy Island, directly opposite Bamburgh and about two miles out to sea. There he built a walled dwelling in which he could be totally enclosed. He was however by no means cut off from the world except when the weather made access impossible. A small house was made for the use of visiting monks and, although he did not leave his cell to mingle with them, many people came to seek his counsel and his prayers. His reputation as a holy man was widely celebrated. In 684 the see of Hexham fell vacant and a synod unanimously elected Cuthbert to the bishop's chair. Initially determined not to leave his hermitage, he was at length persuaded when even the king sailed out to the Inner Farne to plead with him. A transfer of sees was made to enable him to remain based at Lindisfarne instead of moving south to Hexham. While this was doubtless very much to Cuthbert's own taste, it was also in the long-term interests of the Lindisfarne community, who would certainly have been extremely reluctant to see their living saint assigned to another church.

Cuthbert was consecrated bishop in the spring of 685. This appears to mark a stage in the restoration of the independent see of Lindisfarne to the prestigious position which it had

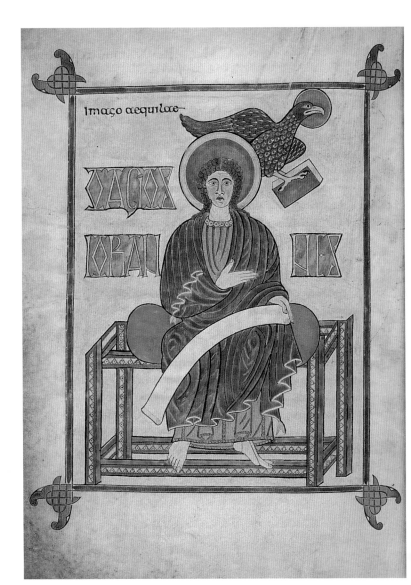

enjoyed before the disasters of 664. For almost two years he carried out his episcopal duties, travelling widely across the north of England. Soon after the Christmas of 686 he returned to the Inner Farne, realising that his final illness was approaching. In his Latin prose life of the saint Bede tells the story of Cuthbert's death in the words of Herefrith, who was abbot of Lindisfarne at the time and who shared the saint's final days. According to Herefrith, Cuthbert had made provision for burial on the island and had to be persuaded to allow his brethren to take his body back to Holy Island. He breathed his last very early in the morning of 20 March 687, the Wednesday of the fourth week in Lent. News of his passing was telegraphed by torches to a brother anxiously awaiting the signal from a high place on Holy Island (probably the Beblowe Crag). Later on the same day his body was taken by boat to the monastery and laid in a stone-lined grave on the right-hand side of the altar in the sanctuary of the church.

For the next eleven years, during the time of Cuthbert's successor, Bishop Eadbert miracles were recorded at the tomb and preparations were made for the eventual elevation of the relics to the altar. Eadbert had the roof and walls of Finan's church encased in lead, a carved wooden coffin was prepared, fragments of which are still preserved at Durham cathedral, and other appropriate accessories were gathered together. It

25
St John
f.209b)

Overleaf
26
St John:
carpet page
(f.210b)
and
27
initial page
(f.211)

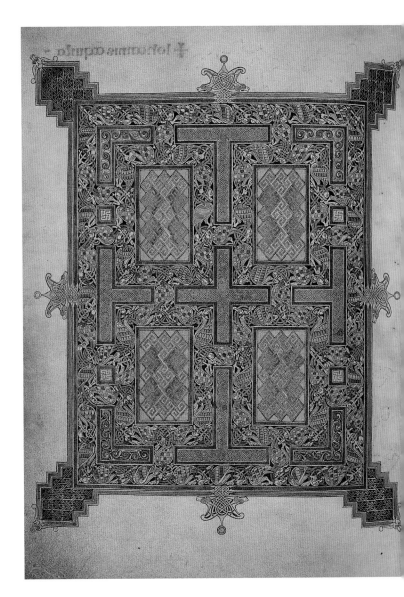

onginneð

incipit · euangelium secundum iohan·

IN PRIN CIPIO ERAT UERBUM ET UERBUM ERAT ABUD OINE OT

was almost certainly at this time that the Lindisfarne Gospels was made. There was no set waiting time to be observed between burial and elevation. Examples to be found in Bede's *History* vary between four years for St Fursey and sixteen for St Etheldrida. All that was required was to allow sufficient time to elapse for the soft parts of the body to disappear, leaving clean bones. The choice of date for Cuthbert's elevation was probably influenced by two considerations. On the one hand Eadbert may already have been showing signs of the illness from which he died in May 698. His body then occupied the tomb vacated by Cuthbert. But almost certainly more significant was the fact that the Easter cycle in 698 exactly duplicated that of 687 so that 20 March, the anniversary of Cuthbert's death and the day chosen for his elevation, was once again the Wednesday of the fourth week in Lent, with an identical liturgical cycle. When the tomb was opened, Cuthbert's body was found to be miraculously incorrupt, in further proof of his sainthood. It was duly placed in its new coffin on the floor of the sanctuary, above the tomb. Eadbert's two successors, the two craftsmen already responsible for the Gospels, both devoted their energies to the promulgation of Cuthbert's cult. Eadfrith, who died in 721, commissioned all three lives of the saint. The first, that of the anonymous monk of Lindisfarne, was written before 705 and has the distinction of

being the earliest English biography. He also restored the hermitage on the Inner Farne. Ethelwald, who died in 740, was responsible for a great stone cross in honour of Cuthbert. The shrine became the focus of great and widespread devotion, adding a new dimension to the status of Lindisfarne and also doubtless generating substantial wealth in the form of offerings in honour of the saint.

HOLY ISLAND was to remain the focal point of Cuthbert's cult for less than two centuries. In 793 the first Viking raid on the English coast struck there, to the dismay of the church. In 875, with great reluctance, Bishop Eardulf decided that he must remove the relics of St Cuthbert and the other treasures of the monastery and seek a safer home. Simeon of Durham gives an account of the subsequent journey of the community. The bones of Eadbert, Eadfrith and Ethelwald accompanied those of the saint, and the Lindisfarne Gospels is mentioned as the central feature of one of the adventures on the way. It had been decided to seek refuge in Ireland but the saint signified his displeasure by raising a storm in which a magnificent copy of the gospels was lost overboard from the ship in which the party was travelling. Once the relics were safely back on English soil, a member of the group was told

in a vision where the book might be recovered. Simeon specifically states that this was the book which Eadfrith wrote with his own hand and it is sobering to realise that, had Cuthbert not so miraculously intervened, the Lindisfarne Gospels might now be in Ireland and Aldred's valuable and revealing colophon would never have been written. Not long after this episode the community settled at Chester-le-Street, moving a century later to Durham where the great romanesque cathedral was built as the ultimate shrine to the premier saint of the north of England. The Lindisfarne Gospels shared the history of St Cuthbert's relics until the Reformation, cherished among the greatest treasures of the cathedral. The book was then seized by Henry VIII's commissioners and sent south to London, where it passed through the hands of Robert Bowyer, Keeper of the Records at the Tower of London, and eventually into the collection of Sir Robert Cotton, where it received its current pressmark of 'Nero D. iv'. Cotton died in 1631. In 1703 his wonderful library was presented to the nation by his heirs. It became one of the foundation collections when the British Museum was founded in 1753 and was transferred to the care of the British Library in 1973.

Today the Lindisfarne Gospels is permanently exhibited in the galleries devoted to the British Library's outstanding treasures, where every year thousands of visitors from all over the

world marvel at the freshness, intricacy and sheer beauty of Eadfrith's decorated pages. For students of the history of the early church in England, this manuscript symbolises the developments of the years during which St Cuthbert himself lived, blending the exuberance of its insular decoration and the distinction of its Irish-derived script with the Vulgate text and evangelist figures based on Italian sources. No other European manuscript of so early a date reflects so clearly the conflicting but ultimately reconciled philosophies and practices of the age which produced it.

Further Reading

J. Backhouse, *The Lindisfarne Gospels*, Phaidon Press, Oxford (in association with the British Library), 1981.

G. Henderson, *From Durrow to Kells: The Insular Gospel-books 650-800*, Thames and Hudson, London, 1987.

The Making of England: Anglo-Saxon Art and Culture AD 600-900, ed. L. Webster and J. Backhouse, British Museum and British Library, London, 1991.

St Cuthbert, His Cult and His Community to AD 1200, ed. G. Bonner, D. Rollason and C. Stancliffe, Boydell Press, Woodbridge, 1989.

Two Lives of St Cuthbert, ed. B. Colgrave, Cambridge University Press, 1940.

Bede's Ecclesiastical History of the English People, ed. B. Colgrave and R.A.B. Mynors, Clarendon Press, Oxford, 1969.

P. Hunter Blair, *Northumbria in the Age of Bede*, Gollancz, London, 1976.

N.J. Highham, *The Kingdom of Northumbria AD 350-1100*, Alan Sutton, Stroud, 1993.

M. Magnusson, *Lindisfarne: the Cradle Island*, Oriel Press, Stocksfield, 1984.

The majority of these books include extensive bibliographies.

Frontispiece: *St Matthew and his symbol (detail of 6)*

Front endpaper: *detail of 16*

Back endpaper: *detail of 2*

Front cover: *detail of 7*

Back cover: *detail of canon tables (f. 15)*

© 1995 The British Library Board
First Published 1995 by
The British Library
Great Russell Street
London WC1B 3DG

British Library Cataloguing in Publication Data
A catalogue record for this title is available from The British Library.
ISBN 0-7123-0400-2

Designed and typeset in Monotype Centaur by Roger Davies, Pleshey, CM3 1HT UK
Colour Origination by York House Graphics, Hanwell
Printed in Italy by Artegrafica, Verona